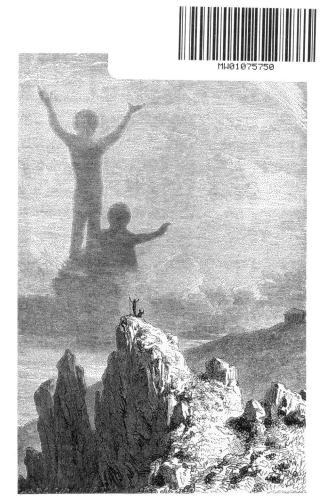

Above: A striking example of shadow projection is the Brockengespenst, or Spectre of the Brocken. This occurs at times on the Brocken, a peak in the Harz Mountains in Germany, when an observer will see a monstrously magnified shadow of themselves cast upon the upper surface of clouds opposite the sun.

First published in the UK in 2021
by Wooden Books Ltd, Glastonbury

Library of Congress Cataloging-in-Publication Data
Vaughan, W.
Shadows

Library of Congress Cataloging-in-Publication
Data has been applied for

ISBN-10: 1-952178-24-X
ISBN-13: 978-1-952178-24-5

Designed and typeset in Glastonbury, UK

Printed in China on 100% FSC
approved sustainable papers by FSC
RR Donnelley Asia Printing Solutions Ltd.

WOODEN
BOOKS

SHADOWS

IN NATURE, LIFE AND ART

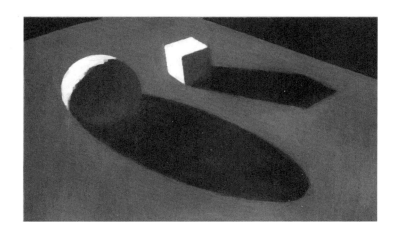

William Vaughan

Many thanks to John Martineau and all at Wooden Books for enhancing my text with such a splendid display. Pippa Lewis contributed much invaluable visual material and Pek Peppin read the text and made many helpful comments. Thanks as well to Simone Sekers for advice on sundials and David Sekers for various suggestions, including drawing my attention to Richard Stine's excellent cartoon, reproduced on page 58.

"I thought the most beautiful thing in the world must be shadow, the million moving shapes and cul-de-sacs of shadow. There was shadow in bureau drawers and closets and suitcases, and shadow under houses and trees and stones, and shadow at the back of people's eyes and smiles, and shadow, miles and miles and miles of it, on the night side of the earth."

Sylvia Plath – *The Bell Jar*

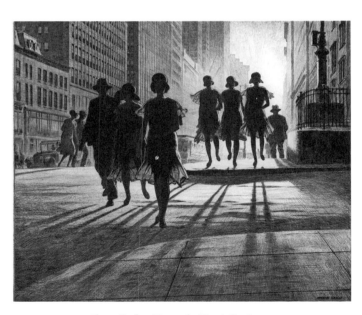

Above: Shadow Dance, by Martin Lewis, 1930.
Courtesy Estate of Martin Lewis, with thanks to Robert Newman.

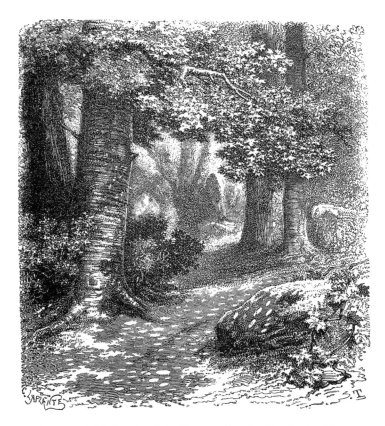

Above: Dappled shade and sunlight, illustration from Sunshine, by Amy Johnson, 1892. Small gaps in the dense canopy acts as pinhole cameras, projecting images of the sun all over the forest floor. During an eclipse these little circles become crescent moons .

INTRODUCTION

WHAT IS A SHADOW? It is an area of darkness, caused when an object obstructs a ray of light. In the figure on the title page, a sphere and a cube are casting shadows caused by them obstructing a light source from the top left. As light travels in straight lines, it cannot curve around an object that it strikes. It therefore passes on either side. The space behind the object remains dark, as does the side of the object not facing the light.

Shadow is intimately related to light. It is the alternative—the yin to the yang of illumination. Together they form one of the elemental dualities in the universe, opposites that need each other to make their character apparent.

Shadows are vital to the way we see. Indeed, our whole being as humans has been fundamentally conditioned by our perception of them. It is believed that mammals first developed sensitivity to shadows because they lived in forests for protection. We humans have long since ceased to need such cover to survive, but our mammalian eyes still have the capability to perceive many of the subtleties of darkness.

This book looks at the nature of shadows and the importance they have for us. It covers shadows in the natural world and in our imaginations. It also looks at how artists have learnt to use shadows, both to master the effects of realistic representation, and as a means of expression and exploration.

The Naming of Parts
source, side, cast and form

ALL SHADOWS are caused when an opaque object gets in the way of a beam of light. Yet the nature of the shadow also depends on its relation to that object.

Usually, when we say shadow we mean *Cast shadow*; that is the shaded area thrown beyond the object that the light is shining on (*opposite top*). However, there is also the shadow that occurs on the side of the object that is opposite the side that is facing the light. This is known as a *Form shadow*. Although it is caused, like the Cast shadow, by an absence of light, its appearance to us is very different. The Form shadow has the effect of helping to reveal the volume of a form.

The Cast shadow can help to give a sense of space and volume. But it has other properties that give it a different kind of significance. It is a projection from the object, and as such it reproduces the shape of the object, often in a distorted form (*e.g. from different light sources, below*). Furthermore, it does not have to be attached to the object. This only happens if the object is resting on a surface. If it is separate from a surface, then the Cast shadow can be completely independent. While useful for dramatic effects, the cast shadow can also be employed for scientific calculations, as will be seen in the next section of the book.

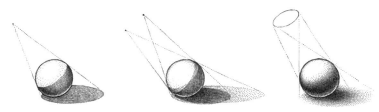

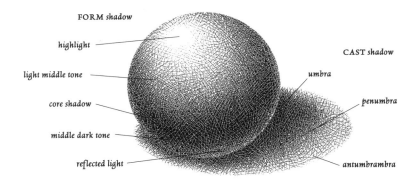

FORM *shadow*

highlight

light middle tone

core shadow

middle dark tone

reflected light

CAST *shadow*

umbra

penumbra

antumbrambra

Above: The various parts of the Form shadow and the Cast shadow. Below: Diagram from Principles of Practical Perspective, by Richard Brown, 1815. Note the moon in the window.

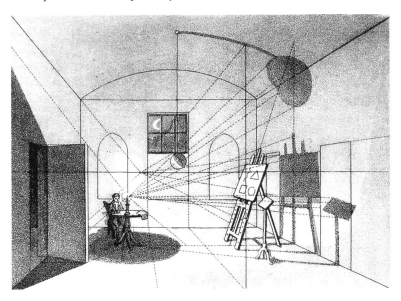

3

3-D SHADOWS
and ambient light

Cast shadows seem to be flat. However, the area of darkness they create is actually a three-dimensional projection.

Imagine a wall with the Sun shining on one side. This casts a flat shadow on the ground on the other side of the wall (*below left*). Now imagine a person standing on that shadow a short distance from the wall (*below centre*), with their upper part in light, receiving the direct rays of the Sun, and their lower part in shadow, where the wall obscures the light. The area of shadow is in fact a three-dimensional triangular prism (*below right*). Most of the dark is not visible as there is nothing for it to strike. But there is an impact in a sense of reduced light.

This effect is also significant as mostly we see shadows in complex situations. The times where there is a single light source creating a single shadow are few and far between. In most situations light does not come from just one source. Even if there is only one source of illumination, this is fragmented by being reflected off different objects, in effect producing multiple sources, each creating its own system of shadow (*lower images, opposite*). The shaded areas we see are usually created from these multiple sources. The resultant effect is known as ambient light, in which light and dark intermingle in a myriad ways.

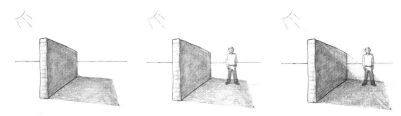

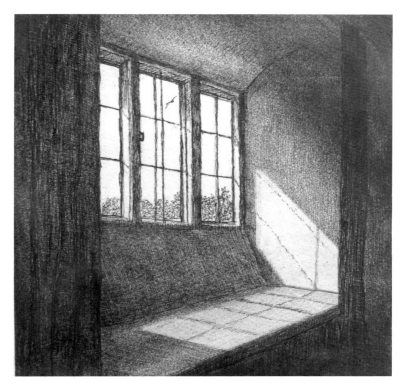

Above: Sunlight, by the author. Sunlight coming through a window forms a sharp projected image – a kind of 'inverse' shadow. It also reflects off the surrounding walls to create ambient shadowing.

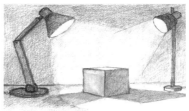

HOW DO WE SEE SHADOWS?
a shadow or a hole?

We see shadows because our eyes have receptors on the retinas that can record the presence of light. There are two kinds of receptors: *Cones*, which discern the three 'primary' colors of light (red, green and blue, a mixture of which creates all the other colors we see), and *Rods*, which only detect green-blue light. Rods tend to be grouped around the outside of the eye and cones at the centre, which is why we see more widely at night than in the day, when there is more of a focus on the central part of our field of vision. Around dusk, both rods and cones are be operating together, which is why everything can appear so blue-green at this time.

Strangely, it is darkness which causes rod and cone cells to fire at full power, whereas increasing levels of light weaken the signal that the receptors send back to the brain. The letters on this page are black and not emitting any light so permit full receptor activity, while the white paper around each black letter stimulates and inhibits receptors. The brain thus presents the black as positive form on a white negative background, a situation which also allows us to 'see' shadows positively as dark patches, even though they are in fact absences of light.

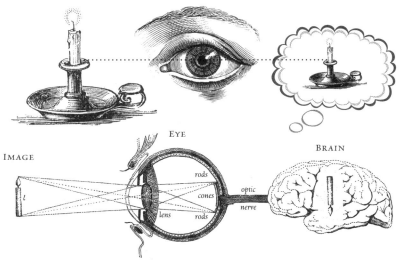

IMAGE EYE BRAIN

rods

cones

lens *rods*

optic

nerve

Above: The human eye is the only exposed part of the brain. Images are presented to the brain inverted, before the brain then flips them the correct way up again.

Left: The Emperor's New Clothes, illustration by Arthur Rackham, 1932.

Facing page: Seeing shadows as dark patches can raise a problem in certain circumstances. When we see black on the ground in front of us it might be a solid piece of ground cast in deep shadow. Or it might be an actual void, a hole in the ground. Usually there are enough subsidiary clues for us to make a decision, but not always. Some animals find it harder than us to make this decision. Cows, it is said, will not go into deep shadow for fear that it is a hole.

NIGHT
the Earth's shadow

Our understanding and perception of shadows starts with those we encounter all around us in the natural world. Rarely do we see a phenomenon in which a shadow does not play its part.

The largest shadow we all experience is that of the Earth. We call it night. It is the part of the Earth that is cast into darkness as the Sun's rays fall. And because the Earth is rotating, all parts of it experience the shadow we call night on a regular basis. This recurring daily pattern of light and dark has formed our nature. As well as regulating our being, the night has offered us sublimity, for it is only because of the Earth's shadow that we are able to glimpse the seeming endlessness of the universe. As the 17th century metaphysician Thomas Browne said ...

> 'Light that makes thing seen, makes some things invisible. Were it not for darkness and the shadow of the earth the noblest part of the creation had remained unseen and the stars in the heavens as invisible as on the forth day'.
>
> Garden of Cyrus, (1658) repub. in Religio Medici, Oxford 1972 ed., p.181

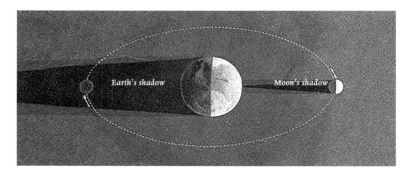

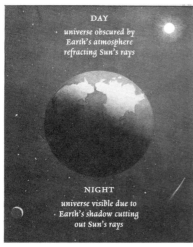

DAY

universe obscured by
Earth's atmosphere
refracting Sun's rays

NIGHT

universe visible due to
Earth's shadow cutting
out Sun's rays

Left: DAY, when we are blinded by sunlight, and NIGHT, when we can see the cosmos.

Below: Moon shadows: The Mill by Moonlight by Gwen Raverat, 1947, and Moonlight on the Tracks by the author.

Only recently, with radio telescopes and space travel, have we been able to see beyond the night sky. Would these devices ever have been developed had there been no inkling of anything beyond? The whole concept of the heavens and celestial beings, indeed, depends on the night vision of the night sky seen by humans from the earliest times. It is an eloquent example of less being more, and represents the deeper and more reflective experience of the world of shadow.

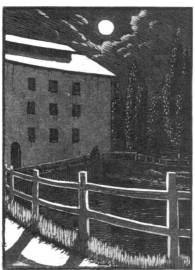

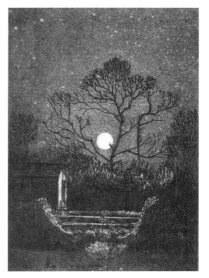

ECLIPSES
shadows of the Sun and Moon

Mostly, we experience the Earth's shadow by being encompassed within it, at night. However, it can be glimpsed in cast form under favourable conditions on the eastern horizon as the Sun sets in the west.

It can be seen even more dramatically when it falls on the Moon. The Moon is, indeed, the only celestial body sufficiently large and close to Earth to be able to act as a screen for the Earth's shadow to fall on. At times, a rising full Moon can appear to be cut off in its lower regions by the Earth's shadow. More dramatic again is the rare occasion when the Earth's shadow cuts across the full Moon when it is high in the sky. This is a lunar eclipse, an eerie sight, as the Moon turns reddish and suddenly seems much more volumetric than usual.

The Moon's shadow, like that of the Earth, is caused by the Sun. Normally, when viewed from Earth, the Moon's shadow is so opaque that it looks as though the shape of the Moon has actually changed. This is why we talk of the Moon waxing and waning, as though it was actually growing and shrinking. As well as affecting the visible shape of the Moon, the lunar shadow can also be cast on the Earth. This occurs during a solar eclipse, when the Moon wholly or partially gets between the Earth and the Sun, causing part of the Earth to be darkened by the Moon's shadow as it is projected on the Earth.

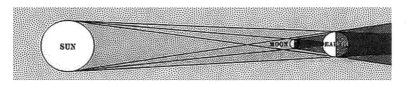

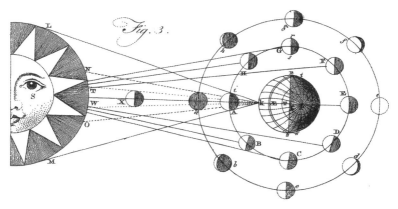

Above: Diagram from the 1771 edition of Encyclopedia Britannica, showing the eight phases of the Moon (new, waxing, quarter, gibbous, full, waning etc) as seen from Earth (outer ring) and the cone of a solar eclipse. The Moon always keeps the same face pointing to the Earth.

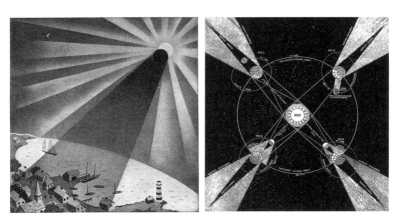

Above left: A solar eclipse, the Moon passing in front of the Sun, from The Illustrated London News, *1912. Above right: Illustration of solar and lunar shadows and eclipses from Asa Smith's* Illustrated Astronomy, *1849. Facing page: Full 'umbra' and partial 'penumbra' shadows.*

MEASURING TIME
sundials

From time immemorial, natural shadows have been used on Earth for making calculations. As the Sun moves through the sky, the position of the shadow it casts changes, with the shortest shadow at noon, enabling the measurement of time. The best known time calculators which use shadows are sundials, and these can be both natural (*e.g. the 'natural sundial' of Castleberg, below, from a 1720 engraving by Samuel Buck*) and man-made (*e.g. from at least c.1500 BC in Ancient Egypt, when sundials were used to measure the times of day, see examples opposite*).

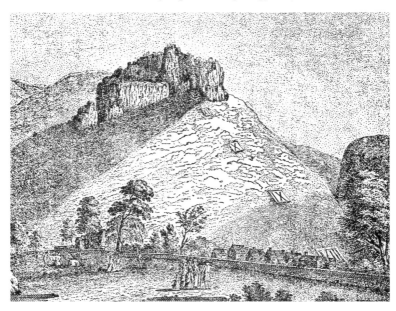

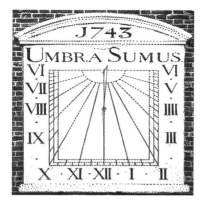

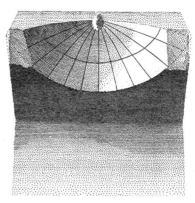

Top left: 'Umbra Sumus' Sundial on the Spitalfields Mosque (a former Huguenot church). 'Pulvis et Umbra sumus' - 'We are but dust and shadow' - is a phrase from an Ode by the Roman poet Horace, often used on sundials. Top right: Model of the c.700 BC Sundial of Ahaz, referred to in the Book of Kings. Left: Window-dial, a string casts a shadow on a wall to tell the time, from Leybourne's Dialling, 1700. Below: Egyptian sundial, c.1200 BC, from the Valley of Kings.

SPACIAL CALCULATIONS
and revealing the invisible

The 6th century BC Greek philosopher Thales is reputed to be the first to recognize that shadows could be used to calculate distances too great to be measured by other means. He used his principle to calculate the height of the Great Pyramid of Cheops at Giza, then the tallest building in the world (*see opposite*).

A few centuries later, Eratosthenes [276–194 BC] calculated the circumference of the Earth based on calculations on the distance between Alexandria and Syene. At a time when sun shone directly down a deep well in Syene, the shadow angle at Alexandria was calculated, and the difference used to calculate the whole circumference.

A projected shadow can also reveal aspects of an object that cannot otherwise be seen. This is because shadows can reveal disturbances that refract light rays, even if such changes are not visible to the naked eye. In modern times this phenomenon (known as a *shadowgram*) has been used in scientific research to reveal non-uniformities in transparent media like air, water or glass (*as shown below*).

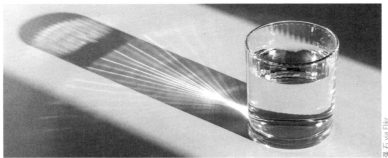

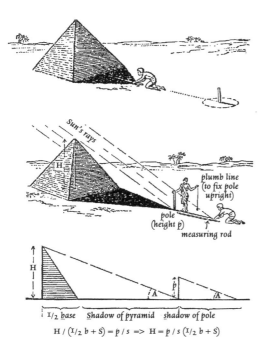

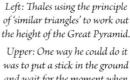

$$H / (\text{\textonehalf } b + S) = p / s \implies H = p / s \, (\text{\textonehalf } b + S)$$

Left: Thales using the principle of 'similar triangles' to work out the height of the Great Pyramid.

Upper: One way he could do it was to put a stick in the ground and wait for the moment when the length of the stick was the same as the length of its shadow. Because the Sun's rays are parallel, the length of the Great Pyramid's shadow at that exact moment (plus half it's base) will equal its height.

Centre: Another way of doing it at any time of day was simply to measure the shadows of the pyramid and a pole and find the height, H, of the pyramid from the fact that the two shadow triangles will be similar.

Lower: The equation for H.

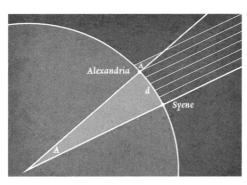

Left: Eratosthenes measured the Earth using the principle of 'similar angles'. He measured the angle A of the shadow of a vertical pole at Alexandria, at a time when the Sun was casting no shadow at Syene, distance d to the south. Finding the angle A to be 1/50 of a circle, he multipled d by 50 to find the circumference of the Earth.

THE SHADOW AND THE SOUL
life is but a walking shadow

IN ONE SENSE all shadows are in the mind. What we see as shadows are what the brain constructs when it receives signals of variations in degrees of light from the eyes. But there is also a psychological response to shadows, most powerful in relation to the cast shadow because of its ability to reproduce the shape of an object in darkened and often distorted form (*e.g. see wood engraving by Gwen Raverat, below*).

Probably the most common association in early societies is that between a person's shadow and their soul. In his celebrated anthropological study, *The Golden Bough*, Sir James Fraser [1854-1941] recorded many instances from Melanesia and China of this association. In China it was the custom at a funeral to keep one's shadow away from the coffin, for fear that your soul would enter it. In Melanesia the association was so close that it was believed that a man could be killed by stabbing his shadow.

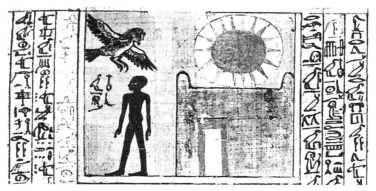

Above: The soul and shadow coming out of the grave at daybreak, papyrus of Neferoubenek, c.1400 BC, Louvre, Paris. The soul and shadow were closely associated in ancient Egypt. A person's shadow (Sheut), one of principal constituents of their soul, contained their features and was always with them. Statues were sometimes referred to as shadows. The shadow was also a figure of death, a servant of Anubis, the dog-headed god of the afterlife.

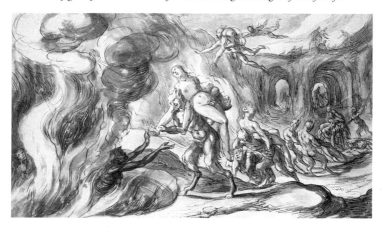

Above: Eurydice in Hell, Herman Weyer, 1620. In Greek and Roman mythology the soul is associated with a shadow, or shade (the soul being one of the two elements of a person, the other being the body). In Hades (the Greek Underworld) the inhabitants are described as shades.

In Plato's Cave

delusion and higher states

Amongst the most influential of imagined shadows are those invoked by the Greek philosopher Plato [429–347 BC]. Unlike the shadows already discussed, Plato's shadows are not surrogates or representatives of the human soul, but are images of delusion.

They occur in an elaborate analogy in Book VII of his *Republic*. In this he (or rather Socrates who he uses as his mouthpiece) uses them to demonstrate the blinkered nature of our experience of reality. He likens us to prisoners in a dark cave, fixed so they can only see straight ahead. Behind them, out of sight, people hold up objects in front of a fire. The prisoners see the shadows of these objects projected onto the wall of the cave. Plato says that the shadows are all the prisoners can know of the objects, and so they mistake the shadows for the substance.

Plato's analogy has been interpreted in many different ways (*see caption opposite*).

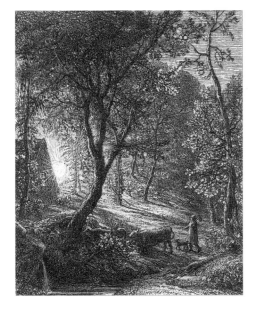

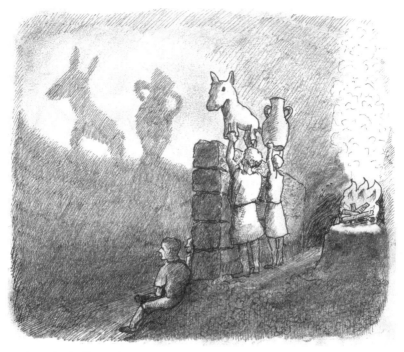

Above: Plato's Allegory of the Cave. For some, the blinkered nature of the experience indicates
the limitations of normal vision—i.e. only through philosophical enquiry and self-investigation
can the shadows be replaced by knowledge of the truth. However, there is a more mystical
interpretation of the story. This is that our whole experience of the world is but the shadow of
a higher reality whose real nature is inevitably beyond our reach. This more mystical idea has
been highly influential through history. In Christian belief, the higher ideal world is interpreted
as Heaven. Neoplatonists such as Plotinus [204–270 AD] held that the occasional intimations
of the ideal that we experience on Earth are glimpses, shadows of this higher state of being.
Such a view is meat and drink for dreamers and idealists, such as the poets Henry Vaughan
[1621–1695] and William Wordsworth [1770–1850]. It encouraged the painter Samuel Palmer
[1805–1881] to use his landscapes to suggest glimpses of a spiritual state beyond the material, as
shown on the facing page in his 1850 drypoint etching, The Herdman's Cottage.

MELANCHOLIA
shadows of the intellect

In the ancient world it was believed that the body was ruled by four humours which controlled the temperaments: *choleric, phlegmatic, sanguine* and *melancholic* (*see below*). Of these, melancholy was the 'black' humour, given to despair and also associated with old age. It was, however, also seen as the intellectual humour, and it is this aspect that made it fashionable in the Renaissance. It also was at this time that it became associated with creativity, an association that has remained.

Dürer's engraving *Melancholia* (*opposite*) is the first and greatest image to explore this relationship. The allegorical figure of melancholy is sunk in contemplation. His face is in shadow, indicative of the darkness of mood and reflection which suddenly gave shadows a new significance. As will be shown later, this was the time when European artists began to develop the use of shadows as a positive part of their pictorial practice.

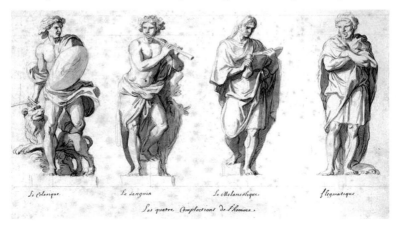

Le Colérique. Le Sanguin Le Mélancolique. Flegmatique

Les quatre Complections de l'Homme.

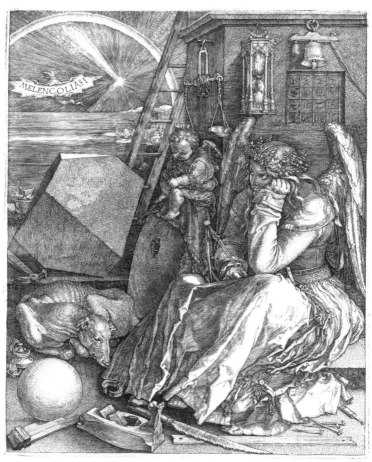

Above: Melancholia, by Albrecht Dürer [1471-1528]. Around the figure are many symbols of the intellectual life and mystical associates—such as the 'magic square' in the background which incorporates the date when the engraving was made [1514]. The print has many interpretations, but it is widely agreed that it is intended to be autobiographical, and that Dürer is seeking to establish the visual artist as a person who is both creative and intellectual.

Fairy Tales
and popular culture

After the rise of Christianity, the use of the shadow as a representation of the soul was not supported in European high culture. However, it remained prominent at the popular level.

One of the most influential treatments in modern times occurs in the story of Peter Schlemihl, by the German poet and botanist Adalbert von Chamisso [1781–1838]. Published in 1814 it has become legendary through its treatment of the theme of the shadow. The complex ramifications of the story are little remembered today, but the image of Schlemihl selling his shadow persisted—particularly after the brilliant interpretation by the English illustrator George Cruikshank [1792–1878], of the Devil folding up Schlemihl's shadow (*opposite top*).

The motif of a person losing their shadow was adopted by many other writers, for example Hans Christian Andersen in his 1847 story *The Shadow (illustration by Vilhelm Pedersen below right)*. In the 20th century, in *Peter Pan*, Peter's shadow was sliced off by a window (*illustration by Marjorie Torrey below left*). His eventual redemption came via Wendy, who had carefully kept his shadow and sewed it back on for him.

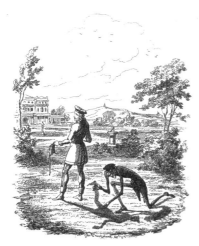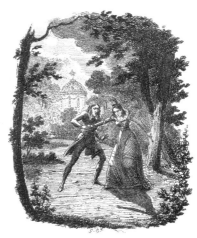

Above: Cruikshank's illustrations for Peter Schlemihl. In the story, Schlemihl, a young innocent, sells his shadow to the Devil in return for a 'bottomless wallet'. But from then on he experiences misfortune after misfortune, as no one will trust a man without a shadow. The Devil eventually offers to sell Schlemihl his shadow back in exchange for his soul, but Schlemihl refuses.

Above: The shadow is often associated with supernatural powers in popular modern fiction. In the crime series The Shadow, a mysterious figure comes to the aid of those in distress.

PSYCHOLOGY
Freud, Jung and shadow as archetype

Since the late 19th century, psychologists and psychoanalysts have engaged with traditional notions of the shadow in developing perceptions of the human psyche.

Sigmund Freud, the creator of psychoanalysis, took a negative view of the shadow. It represented for him the dark unconscious urges in human beings. These were the instincts his analytical process was intended to expose and to help us control.

His pupil and rival Carl Jung, however, took a more positive view. Keen to engage with traditional wisdom, he developed a notion of 'archetypes' in the human psyche, which he felt were innate and universal, part of a 'collective' unconscious. He saw the shadow as the one that engaged with the primal aspects of humanity, in particular sex and life instincts. It thus represented wildness, chaos and the unknown. Often it manifested itself to people in dreams, taking the form of an adversary, monster or wild animal.

WHO KNOWS what evil lurks in men's hearts?
— THE SHADOW KNOWS —

IT'S HARD to get rid of the demons inside you because they hold you when no-one else does.

OUTER WORLD

PERSONA

EGO

Consciousness — Consciousnes

Personal Unconscious — Personal Unconscious

SELF

Collective Unconscious — Collective Unconscious

SHADOW

Anima-Animus

INNER WORLD

Above: The Jungian picture of the human psyche, which requires a fully integrated shadow for a healthy self. Below and facing page: Popular cartoons expressing the various ways the shadow operates in human nature.

Above: Carl Jung famously argued: "How can I be substantial if I do not cast a shadow? I must have a dark side if I am to be whole." Too many people, he said, deny the power of their shadow, which is a vital force and important source of creativity. This is very similar to the ancient Chinese concept of 'Yin and Yang,' where light and dark are the mirror opposites of each other, intertwined, interdependent and balancing each other.

"ONE DOES NOT become enlightened by imagining figures of light, but by making the darkness conscious"

C G Jung

THE SHADOW:
Evasion and Confrontation

1. Recognising the Shadow

2. Running from the Shadow

IN PRAISE OF SHADOWS
views from the east

In the 1930s, a striking exploration of a positive view of shadows from an Eastern perspective was published by the Japanese novelist Junichiro Tanizake. *In Praise of Shadows* set the oriental appreciation of the subtlety of shadows against the negative view of them in the Western world. Tanizaki saw modernism as a western celebration of light and action. He saw the shadow as the symbol of subtlety and contemplation, traditional attributes of oriental wisdom and aesthetics, arguing "Were it not for shadows, there would be no beauty". While the West had focussed on shadows as images of darkness and menace, including the ghostly mimicry of humans in the cast shadow, Tanizaki looked to the subtlety and acceptance that shadows bring.

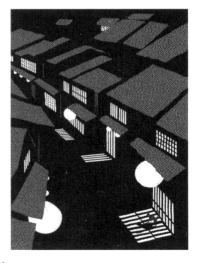

"We Orientals seek our satisfactions in whatever surroundings we happen to find ourselves, to content ourselves with things as they are, and so darkness causes us no discontent, we resign ourselves to it as inevitable. If light is scarce then light is scarce; we will immerse ourselves in the darkness and there discover its own particular beauty. But the progressive Westerner is determined always to better his lot. From candle to oil lamp, oil lamp to gaslight, gaslight to electric light — his quest for a brighter light never ceases, he spares no pains to eradicate even the minutest shadow."

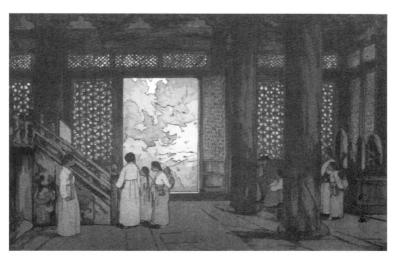

Above: Shokei Palace by Hiroshi Yoshida [1876-1950]. Japanese interiors employ shadows and view darkness as an essential part of being. Below: Pastel after photograph by Hiroshi Sugimoto.

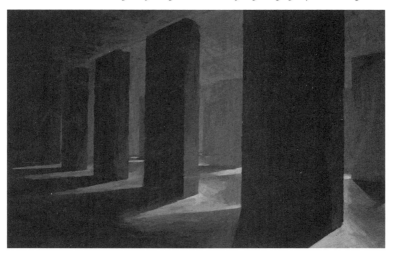

THE ORIGINS OF ART
the shadow myth

HOW HUMANS FIRST CAME TO MAKE IMAGES remains a mystery. The earliest known works of art are marks and tracings inscribed on rocks (*see below and opposite*), some created by Neanderthals long before the arrival of Homo Sapiens. In Western Europe, the popular classical story of Butades recounts how image-making began with a shadow (*see opposite top*). The story is recorded around 77-79 AD by the Roman historian Pliny in his *Natural History*, who places the occurrence in Greece: *"Some say that it was invented at Sicyon, others at Corinth; but they all agree that it originated in tracing lines round the human shadow."*

This description is interesting in that it foregrounds the use of the shadow. Western art is the only pictorial tradition that has relied on shadows to construct images. The use relates less to the actual origins of picture-making than to the Greek view that art should be based on *mimesis*—the exact imitation of forms as they appear in nature, long used as a sign of the superiority of the Western artistic tradition over that of other cultures.

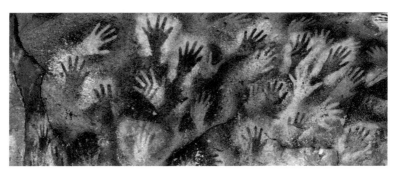

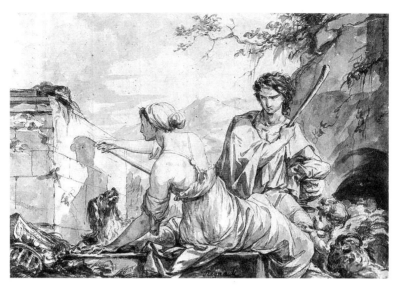

Above: Butades was a Corinthian potter. His daughter traced the profile of the face of her lover, thrown by a lamp on a wall, as a record of him before he departed on a long journey. From this, her father then modeled his face in clay. Watercolor by Jean Baptiste Regnault [1754-1829].

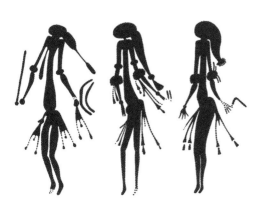

Facing page: Painted hand shadows from The Cave of the Hands, Argentia, c.11,000 BC. The earliest known human art is of hand shadows similar to these, painted c.70,000 BC by Neanderthals in the Maltravieso Cave in Spain.

Left: Three shadow figures from the Bradshaw rock paintings, Western Australia, c. 18,000 BC, after G. L. Walsh.

SKIAGRAPHIA
shadows and illusion

In their pursuit of art as the imitation of nature, the Greeks also used shadow for a critical innovation. This was the introduction of shading to create the illusion of three-dimensional forms on a two-dimensional surface. Traditionally the invention has been ascribed to the 5th century BC Athenian painter Apollodoros. It was termed *skiagraphia*, that is, 'shadow painting' in recognition of the critical role that shadow played in creating this effect.

Unfortunately, no works by Appolodoros have survived, so it is hard to say how far he took the representation of shadow. Examples elsewhere in Greek art—and in the Romans who imitated them—suggest that skiagraphia was more connected with giving shading to figures, that is 'attached shadows', than to effects of cast shadow. However, frescos dating to the 4th century BC found in the Macedonian tomb of Agios Athanasios in Thessaloniki (*see example below*) show faces in partial shadow as well as cast body shadows, demonstrating that both types were well understood by at least some artists of this period, even though the full dramatic potential of cast shadow and ambient lighting were not exploited (*see too example opposite*).

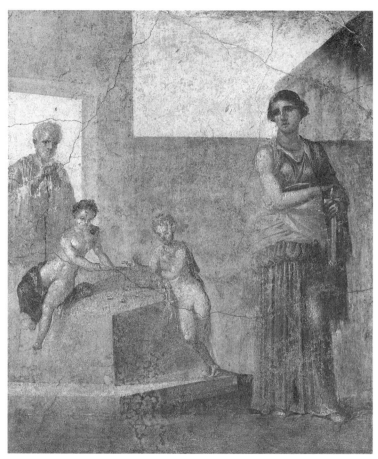

Above: Roman mural, c.50AD, from the Casa dei Dioscuri in Pompeii showing Medea planning the murder of her children. The children, playing knucklebones, are clearly shown with shading on their bodies, and the platform on which they play casts a shadow in the direction of Medea, who appears to be standing in shade as she contemplates committing her spiteful crime—perhaps an early example of the use of shadow for dramatic effect.

SCULPTURE
shadow and relief

Long before the Greeks innovated skiagraphia, sculptors were using natural light effects to articulate form in their figures. As three-dimensional forms, sculptures naturally cast shadows (when viewed in any form of light) which play an important part in the understanding of the sculpture's form (*e.g. see Bacchus and Satyr, by Jan de Bisschop, opposite*).

Relief sculpture makes use of natural shadows in a very precise manner, and dates back to the Paleolithic period. The earliest known example is the Venus of Laussel, from south-western France, which dates to c.23,000BC (*opposite top right*). The practice became widespread as ancient civilizations exploited the subtle effects that could be obtained by use of ridges and hollows. The c.1300 BC relief of the Sumerian Marduk in the Louvre (*below*) makes particular use of this in the patterning on the wings of the mythical figure, and in a ridge which is employed to highlight the deity's commanding eyebrow.

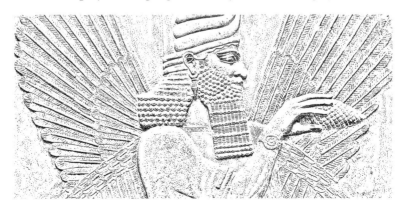

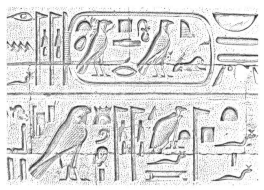

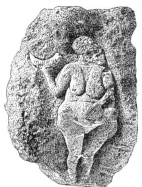

Relief sculpture was made by many ancient civilizations.
A speciality of Egyptian art is the use of the sunken relief
which leads to particularly sharp shadow effects. Above left:
Hieroglyphs from the Temple of Ombos, Egypt, c. 200 BC;
Above right: the Venus of Laussel, c.23,000 BC; Below left:
12th C. carving of Apsaras, Angkor Wat, Cambodia; Below
right: Bacchus and Satyr, 1670 etching by Jan de Bisschop,
after a 1497 sculpture by Michaelangelo.

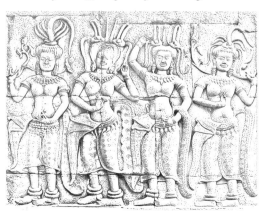

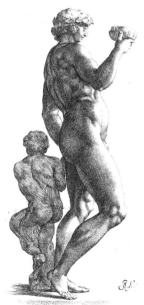

THE REBIRTH OF THE SHADOW
renaissance art and the 'smokey' look

While the shadow is not altogether absent in medieval art, there was no advance in its usage until the Renaissance. In the 15th century, technical developments in oil painting, together with the age-old desire to increase realistic representation, pushed the form to new heights. Oil painting, with its glazes and enhanced transparency, could now capture nuances of light with a new subtlety.

While oil painting was innovated in the Netherlands, it was in Italy that the new approach to shadows was fully formulated. The architect and theorist Alberti mentioned the usefulness of cast shadows in developing his theory of perspective in his 1464 treatise *De Statua*.

The matter was then taken further by Leonardo da Vinci, who wrote five treatises on the use of shadows. Drawing on the resources of oil, he developed a technique, known as *sfumato*, 'blurred' or 'vague', from the Italian word for smoke. This enabled him to explore shadows of immense subtlety, lending shading a wistful nature never before known. Interestingly, Leonardo was against all stark forms of shadowing, and specifically said in one of his treatise that artists should avoid cast shadows, because of their distorting effects.

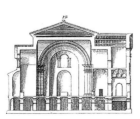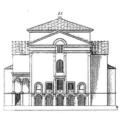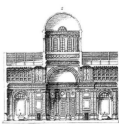

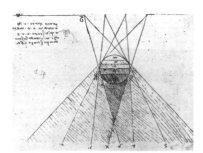

Above: Sketch by Leonardo Da Vinci, showing how to calculate and draw the umbra and penumbra of a sphere.

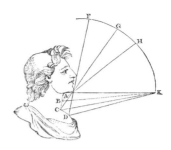

Above: Leonardo Da Vinci's technique for determining the relative shade values of the lower chin, neck and breast.

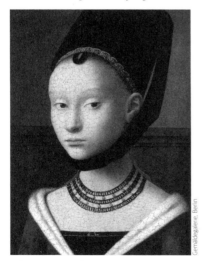

Gemäldegalerie, Berlin

Above: Portrait of a Young Woman, by Dutch painter Petrus Christus [c1415-1475]. The shading on the right side of the face shows an early grasp of the sfumato technique.

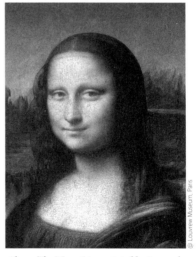

© Louvrew Museum, Paris

Above: The Mona Lisa, painted by Leonardo Da Vinci in 1503, brilliantly uses sfumato shading to create the subtle enigma of the famous Mona Lisa smile.

DRAWING SHADOWS
perspective and treatment

One of the great visual innovations of the Renaissance was the application of mathematics to the precise drawing of spatial recession in pictures. This achievement made it possible to draw exact shadows for the first time. From Italy to the Netherlands, artists could now not only draw objects in perfect perspective, but these objects' shadows too, and the basic techniques have remained the same to this day.

The projection of shadows in pespective and technical drawings is known as *sciagraphy*. The facing page shows two images from a typical perspective sketchbook, plus two examples of accurate shadow projection using plan and elevation. Single point light sources, such as the Sun, lend themselves to such techniques as they cast shadows with well-defined edges. Multiple light sources and closer wider beams present further challenges (*e.g. see illustration on page 2*).

There are many different techniques for rendering shadows. The impressionist painter Pierre-Auguste Renoir [1841-1919] once said: "No shadow is black, it always has a color. Nature knows only colors, and white and black are not colors." Vincent Van Gogh [1853-1890] famously mixed vivid greens and purples into his shadows. Pencil or charcoal shadows can be blended and smudged, and even with pen and ink alone there are distict types of shading (*below: i. stippling; ii.contours; iii. hatching; iv. scumbling; v. cross-hatching; and vi. scribbling*).

i. *ii.* *iii.* *iv.* *v.* *vi.*

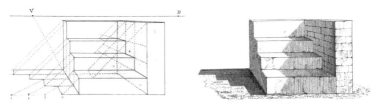

Above: The position of shadows falling from steps can be calculated once the angle of the light is known. The sun casts rays at a fixed angle. Shadows share the same vanishing point as the steps.

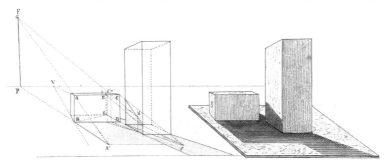

Above: Drawing accurate shadows cast by a point light source using simple geometry. Diagrams from the sketchbook of Alph Bourgez, Paris, 1880 (courtesy Victor Wynd).

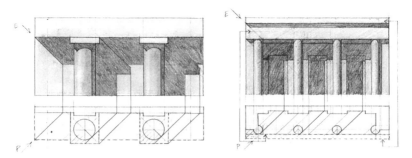

Above: Two examples of sciagraphy, by Chelsey Tennis. Using architectural/engineering plan and elevation drawings, highly accurate shadows can be projected and shaded to add realism.

SHADOW IN ARCHITECTURE
precision and perspective

Shadow has always formed a strong part of the effects of architecture. In traditional European architecture, as elsewhere (*see page 26*), there is a history of using shadow to create contrast, mystery, interiority and reflection, as can be seen for example in the interiors of the great Gothic cathedrals of the middle ages (*see opposite*).

With the coming of the Renaissance there developed a tendency to explore shadow more in terms of the articulation of form. Form became the enhancer of effects of light. As the American architect Louis Kahn put it, "Material casts a shadow, and the shadow belongs to light." The new resources provided by mathematical perspective, drawings and prints since the Renaissance emphasize this tendency.

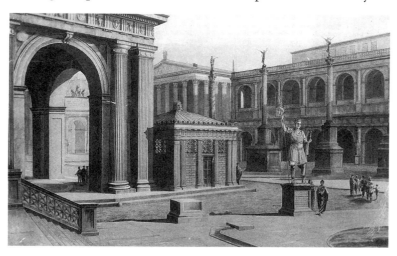

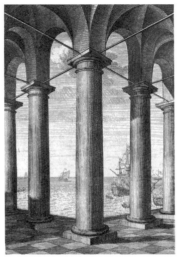

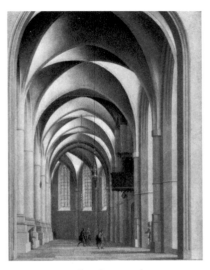

Above left: Engraving of a colonnade from the Treatise on Art and Architecture *by Renaissance architect Leon Battista, showing the use of shadow to enhance the power and grandeur of form. Above right: Choir of St. Bavo Haarlem, Netherlands, by Pieter Jansz. Saenredam [1597-1665].*

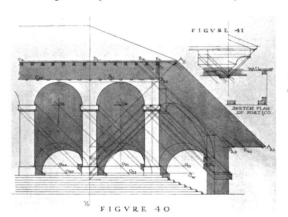

Left: A plate from Henry McGoodwin's 1904 treatise Architectural Shades and Shadows, *which shows the extent to which shade forms a part of an architect's plans.*

Facing page: Artist's impression of the Roman Forum in the golden era of Classical Rome. Areas of shade were designed for aesthetic purposes (to enhance form) but also for keeping cool, or dry.

CARAVAGIO & CHIAROSCURO
and the cast shadow

Leonardo had advised painters against using cast shadows because of their lack of elegance and their tendency to exaggerate form. A century later, however, the Italian painter Caravaggio [1571-1610] began to use strong cast shadows in his paintings, demonstrating that it was precisely this that made them so theatrical and arresting.

In *The Calling of St. Matthew (opposite top)*, painted in 1600, Caravaggio shows Matthew, a tax gatherer, carousing with friends when Christ comes to summon him. A raking light falls on them, throwing their profiles into relief. A cast shadow, thrown by a wall outside the picture forms a sharp line of darkness leading towards Matthew from Christ, whose commanding hand is highlighted against it.

Caravaggio was working in Rome, and the Italian word *chiaro-scuro* (light-dark) was used to describe this method. He soon had imitators throughout Europe, Rembrandt [1606-1669] among them.

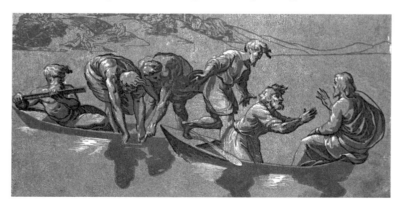

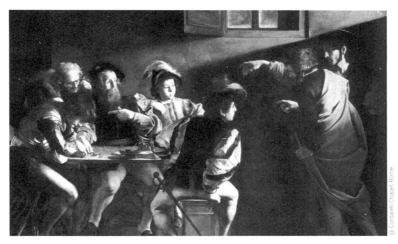

Above: Caravaggio uses shadows to articulate an old story in a new and arresting way, giving his picture the immediacy of a theatrical performance. Below: Rembrandt's 1649 etching Christ Healing the Sick *uses chiaroscuro to strengthen his composition. Facing page: The* Miraculous Draught of Fishes, *chiaroscuro woodcut, Ugo da Carpi, c. 1525, Albertina Museum, Vienna.*

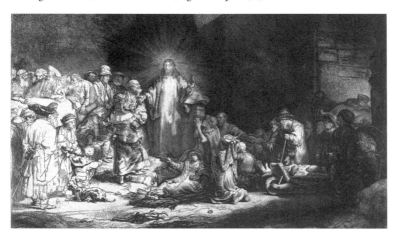

Rembrandt
and the ambient shadow

The great Dutch painter Rembrandt gave chiaroscuro a new sense of depth and introspection by combining the dramatic effects of cast shadow with the subtle nuances of ambient shadows. In some ways he was responding to the subtlety of Leonardo's sfumato, but whereas Leonardo used this to convey a mysterious sense of beauty, Rembrandt was more interested in using it to explore the details of ordinary humanity. A master of exploring the crevices of old age, he observed his fellow humans with tenderness and a perceptive exploration of light and shadow, typical of Dutch artists of his time.

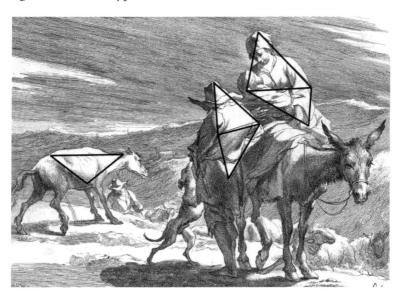

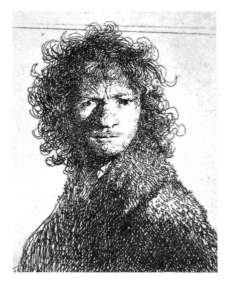

Left: Rembrandt, *Self Portrait with Angry Expression c.1630*. Rembrandt's use of half-light led to the development of a form of portraiture now known as 'Rembrandt lighting,' widely used in early movies, which employs small triangles of light, particularly on a subject's otherwise unlit cheek (which can be very flattering for people with prominent cheekbones). Facing page: Analysis of 'Rembrandt triangles' in an etching by Johannes Visscher [1633-1692]. Below left: *Head of Monk in Prayer*, showing 'Rembrandt triangle' on nose, etching by Charles Emile Jacque [1813-1894]. Below right: Detail from *La Ronde de Nuit*, showing ambient shadows, etching by Charles-Albert Waltner [1846-1925] after Rembrandt.

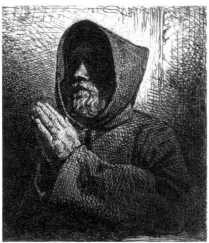

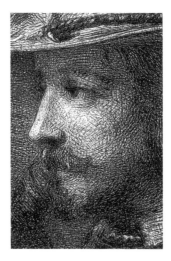

THE ENLIGHTENMENT
Lavater and silhouette portraiture

In the 18th century, the Swiss-German writer Johann Kaspar Lavater [1741-1801] invented an *Apparatus for Taking Silhouettes* which could trace the profile of an individual from their shadow (*see sketch from 1783, below*). Lavater believed that the proportions of a person's silhouette gave an objective indication of their character—one of the now discredited techniques of the period that tried to stereotype individuals and racial types by physical appearance.

The technique attracted a lot of attention at the time, and outline portraits based on shadows became a fashion around 1800. The author Jane Austen was one of those who had such an image made (*opposite*).

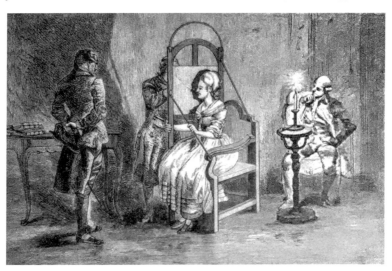

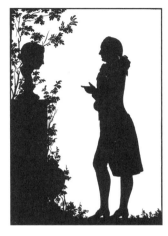

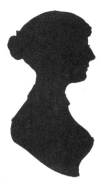

*Left: Silhouette of J. W. Goethe standing in front
of a bust of Charlotte von Stein, drawn c. 1780.
Above: Silhouette of Jane Austin, 1815.*

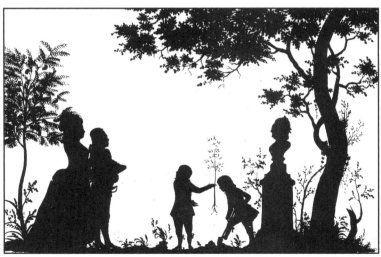

*Above: Silhouettes incorporated into settings. Grand Duke Pavel Petrovich, Grand Duchess
Maria Feodorovna and sons planting a tree in front of a bust of Catherine II, Russia, 1784.*

CHINESE SHADOWS
and projected movement

The interest in silhouettes in the 18th century was also inspired by the growing knowledge of the ancient Chinese art of shadow puppetry. According to legend this developed around 100 BC during the Han dynasty, after the magician Shao-weng observed children making shadow figures with parasols in the mid-day sun. He used this to cheer up Emperor Wu of Han, mourning the loss of a favourite concubine.

The process was known as *Ombres chinois* (Chinese shadows) when it was first copied in the west. In a performance, cut-out figures are held between a light source and a translucent screen. Early performances were dim affairs, but the development of the magic lantern (*see page 48*) transformed the process, magnifying and projecting the images onto a screen in front of the audience.

The effects achieved also encouraged the game of making images from hands held in front of a light source (*opposite top*), an art known as *shadography*.

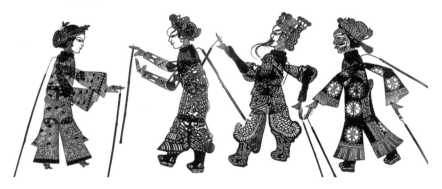

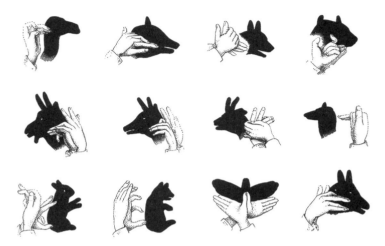

Above: Hand shadow figures, or 'shadographs' were a popular hobby in the 19th century.
Below: Sheets of figures for Chinese shadow puppet shows, 1859, designed by Juan Llorens.
Facing page: 18th century Chinese shadow puppets with jointed arms and sticks.

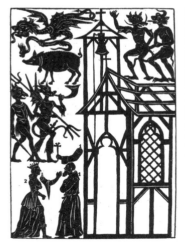
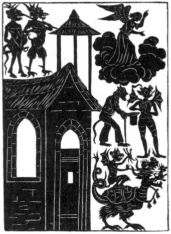

THE MAGIC LANTERN
projected shadow and fantasy

While the projected image was leading to a particular type of portraiture, it was also fuelling a new development in visual display. This was the enlarged projection of images on a wall or screen by means of a 'Magic Lantern' (*see below*). Invented in the 17th century, the process became highly popular in the later 18th century, when advances in lenses and more powerful light sources made it possible to project images.

While the shadow of the silhouette portrait was a form of analysis, the magic lantern exploited the potential for drama. It remained a firm favourite for entertainment throughout the 19th century and was eventually to provide the basis for the development of 20th century cinema (*see page 54*), which used the same principle of projection.

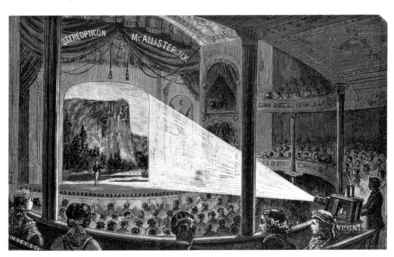

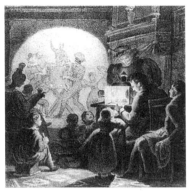

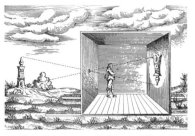

Above: An early Magic Lantern show, c.1820. Note the impromptu use of cast shadow for fantasies created by the hand.

Above: Engraving of a Camera Obscura. These ancient devices became popular in the late 16th century. They allowed a viewer in a dark box to view an inverted image of the outside world, cast through a small hole. The principle involved is very similar to that of the magic lantern, and later slide projectors.

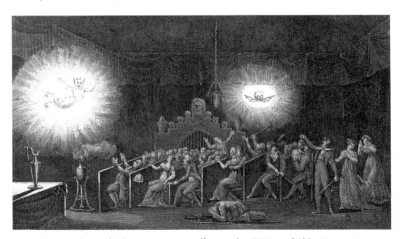

Above: Robertson's Phantasmagoria, as illustrated in F. Marion's L'Optique, 1867. Hidden magic lanterns were used to project images of skeletons, demons and ghosts on to walls, screens, sheets and smoke, accompanied by sound effects to terrify audiences. The shows evolved from tricks developed for seances in Germany in the late 18th century.

ROMANTICS
and other mysterious shadows

ARTISTS OF THE ROMANTIC ERA were fascinated by the way the Magic Lantern had reclaimed the shadow for metaphysics and fantasy. A key example was the 'visionary' landscape artist Samuel Palmer [1805-1881], friend of the prophetic poet, painter and printmaker William Blake [1757-1827], who sought a vision of the otherworld in nature.

In his memoir, Palmer recalls as a boy seeing the shadows of an elm branch cast by the moon against a wall. This stirred ideas similar to Plato's, of the natural world being a shadow of a higher reality (*see page 18*). Palmer was fascinated by the transformation the shadow gave to the form of the tree, suggesting its potential to lead us beyond the everyday. "I have never forgotten those shadows" he commented "and have frequently been trying to draw them". And indeed, many of his most suggestive tree forms seem based on mysterious shadows.

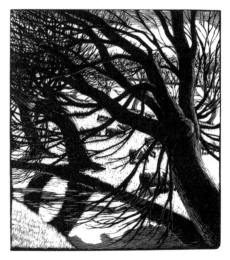

In the 20th century, wood engravers such as Darwin's grand-daughter, Gwen Raverat [1885-1957] further explored the shadows and reflections of trees (*e.g. her 1935 print 'The Fen, a Cambridge Landscape', inset right*).

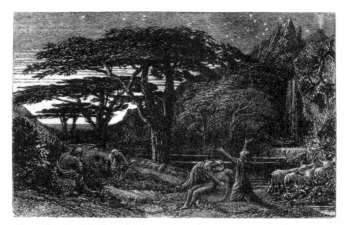

Examples of work by Samuel Palmer. Above: The Cyprus Grove, *etching c. 1868.*
Below: Moonlight, a Landscape with Sheep, *watercolor, 1832.*

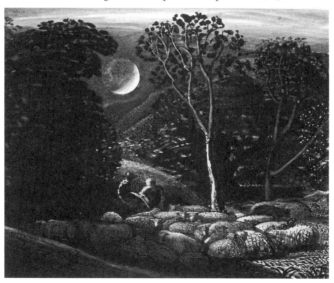

THE SHADOW IN MODERN ART
shadowlessness and expressionism

With the decline of interest in literal realism, the key position that the shadow had occupied in western art as a means of creating an illusion of reality became challenged. The Impressionists, concerned to capture the effects of color and light, declared that shadows were to be seen as areas of color rather than darkness. Claude Monet [1840-1926] demonstrated this in pictures like his haystacks (*opposite top right*) where the shadow of the stack is given a purplish coloring that 'compliments' the yellow of the surrounding field. Subsequent painters took the obsession with color to the point where shadows disappeared altogether. Henri Matisse [1869-1954] replaced shadows with strong patterns and vibrant colors (*opposite top left*) and shadowlessness also triumphed in a form of naieve realism that was particularly practiced by the painter L. S. Lowry [1887-1976] (*lower, opposite*).

In symbolism and expressionism the shadow was used to suggest the sinister and the unknown. In his 1895 painting *Puberty* (*inset right*), Edvard Munch [1863-1944] uses the shadow of a young girl sitting naked on the bed to signify the fear and uncertainly of awakening sexuality, an image of the unknown and uncontrollable soon to come.

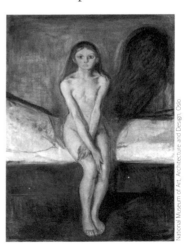

National Museum of Art, Architecture and Design, Oslo

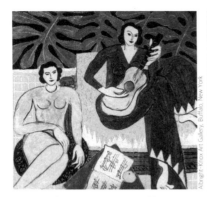

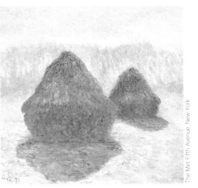

Above left: La Musique, painted by Matisse in 1939, uses color and outlines but no shadows.
Above right: Two of Monet's many paintings of haystacks, which use purple for shadows.

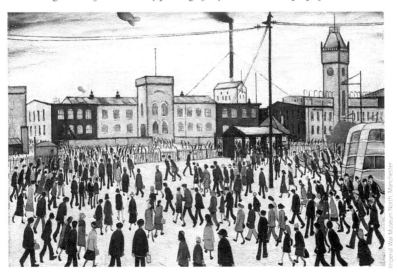

Above: L.S. Lowry, Going to Work, 1944. The absence of cast shadows gives an unique
poignancy to his figures, subtly emphasizing their sense of isolation in the industrial landscape.

Filmic Shadows
from expressionism to the silver screen

The cinema is perhaps the ultimate art of shadows. The heir to Plato's cave, it tells us tales by projecting shadows on a wall as we sit in darkness, something which must have been more evident in the days when cinema was still the projection of an image from an actual piece of film, and largely in black and white. In these early days, the projected shadow was explored by film makers within the narrative of their films.

Perhaps the most dramatic and experimental use of shadows came when avant-garde artists began to use the cinema as an art form. The influence of expressionist art in early German cinema, along with the widespread use of chiaroscuro (*see page 40*) and Russian editing techniques were all soon adopted in Hollywood.

In the days of the silver screen, the absence of color placed an emphasis on form and the effects of the projected shadow. As well as Caligari–style exaggeration (*opposite top left*) there was the use of shadow to express internal reflective moments. Cecil De Mille [1881-1959] adopted 'Rembrandt shadows' (*see page 42*) to film deeply shaded faces, giving them more drama and expression.

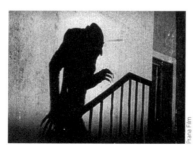
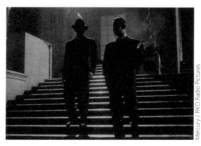

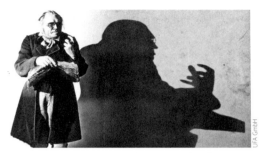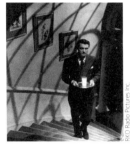

Above left: In The Cabinet of D. Caligari (1920), an exaggerated projected shadow is used to expose the sinister side of Dr. Calgiari. Above right: Hitchcock uses shadows in Suspicion (1941).

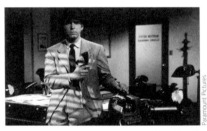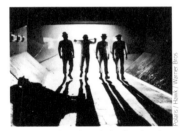

Above left: In Double Indemnity (1944) Billy Wilder employs 'Rembrandt shadows' and special projection effects, as the leading figure reflects on the complexities of the situation. Above right: Stanley Kubrick uses shadows to brutal effect in A Clockwork Orange, 1971.

Above left: Director Frank Tuttle layers his shadows in This Gun for Hire, 1942. Above right and facing page right: Ambient and back shadows from Orson Wells' epic Citizen Kane, 1941. Facing page left: The vampire from Nosferatu, 1922, directed by F. W. Murnau.

Shadows and Paradox
imagine the unexpected

New possibilities for irrational and paradoxical uses for shadows were explored in the Surrealist movement. In *The Mystery and Melancholy of the Street (opposite top left)*, Giorgio de Chirico [1888-1978] creates a sense of foreboding by the cast shadow of a hidden figure in the background and the curious reduction of the girl in the foreground to a pure silhouette, like a cast shadow that has suddenly taken on a life of its own. In a post-Freudian world these visual dreams had a new psychological power.

Taking a more mathematical approach, the master of the visual puzzle, Maurice Escher [1898-1972], played with shadows in his reversals of forms. In *Day and Night (below)* he plays with light and dark, with light birds flying over a nocturnal landscape while the shadows of their forms fly over the same scene reversed and in daytime.

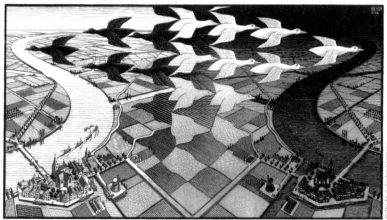

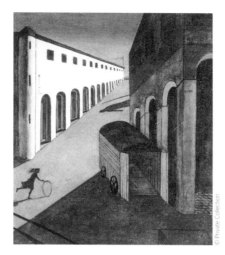

Left: *The Mystery and Melancholy of the Street*, by Giorgio de Chirico, 1914.

Below: *Self and Notself II*, by Antony Gormley, 1996, carbon and casein on paper, 14 x 19cm, © the artist. In another of his works, Gormley required the spectator to place his feet on a marker. The spectator's projected shadow then became the sculpture, symbolising the way modern alienation reduces us to a shadow of ourselves.

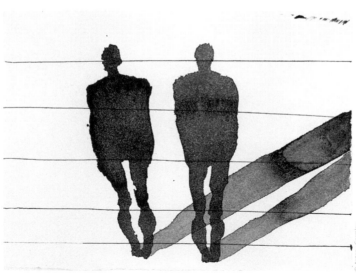

THE PERSISTENCE OF SHADOWS
the eternal chase

Despite the critique mounted by artistic modernism, shadows in art persist. As their use by Gormley shows, they have lost none of their power and impact in the contemporary world. It is a sign of this, too, that the construction of shadows has played such an important part in the development of digital modelling in computer graphics.

Shadows surround us still, both in art and life.

HIS FORMER SHELF

SHADOW OF HIS FORMER SHELF

STINE